101

REASONS

TO

SHOP

"A girl should be
two things:
classy and fabulous."

COCO CHANEL

*it*books

AN IMPRINT OF HARPERCOLLINS *PUBLISHERS*

101

REASONS

TO

SHOP

JESSICA WALDORF

Illustrations by Carly Monardo

*it*books

HarperCollins books may be purchased for educational, business, or sales promotional use. For information please write: Special Markets Department, HarperCollins Publishers, 10 East 53rd Street, New York, NY 10022.

FIRST EDITION

Designed by Mary Austin Speaker

Library of Congress Cataloging-in-Publication Data is available upon request.

ISBN 978-0-06-204517-1

11 12 13 14 15 ov/QG 10 9 8 7 6 5 4 3 2 1

For Aunt Sassy,
who always permitted me to indulge

"I always say shopping
is cheaper than a psychiatrist."

TAMMY FAYE BAKKER

Acknowledgments

This book was the result of many years of research, tirelessly slogging from one store to another in the search of a great sale or a passable bridesmaid dress or jeans that didn't make my butt look too big. Thus I owe a great deal of thanks to my shopping partners-in-crime: Amy Bowles, Katie McHugh, Michelle Brower, Joanne Sturgeon, and all of the wonderful, fashionable Sturgeon sisters. Thanks also to the handsome Matthew Sears, whose love for Express knows no bounds. Matt, you make shopping fun.

To Stephanie Meyers, my editor, the loveliest, most stylish, yet most down-to-earth shopaholic I know, for loaning me amazing dresses when I needed them, and for inspiring several of these excuses. To her mother, and mine, for raising fabulous daughters. And to everyone at HarperCollins for believing in the book.

Finally I'd be remiss if I didn't thank my wonderful illustrator, Carly Monardo, whose creative mind, sharp hand, and dedicated enthusiasm brought the material to life (and made me want to buy half the outfits in this book). Please check out more of her work at www.whirringblender.com.

Contents

Introduction: Shopping Under the Influence

Everyone can relate to the joy of walking into a store empty-handed and walking out with crisp, exciting, attractive, shiny new things: furniture that matches the dream house in our imagination; perfume that lifts our mood like a field of daisies; clothes that have the power to improve our lives, impress the boss, or compel the cute neighbor to exclaim "I love your shoes!"

Everyone probably also has heard that nagging little voice reminding us to avoid consumerism, forgo the superficial acquisition of unnecessary stuff, and remember that true beauty comes from the inside. For those of us who just can't resist the siren call of the mall, this all can lead to feelings of guilt. Did I really *need* that leather jacket, the one that made me look slightly tough, but chic, and most importantly *slim* at the same time? How many times am I really going to wear that vintage polka-dot swing dress, the one that makes me feel like a kept woman off the set of *Mad Men*? What about the matching pumps, so painful I can only wear them an hour at a time?

The truth is, there are a lot of pros to shopping, but women often hear only the negatives: it promotes materialism, leads to bad debt, destroys self-control, etc. (And if those are your issues, I would certainly recommend some restraint, and perhaps that your next purchase be a book on budgeting.) But what about the myriad *positive* benefits of shopping: bonding with friends, putting your best foot forward, and helping to save the economy's sinking ship? How about the skills you learn, including negotiation tactics, decision-making, and color-coordination? And what's wrong with loving fashion and taking pride in your looks? Beauty is an art form, and meant to be celebrated . . . with a trip to Bergdorf, if possible!

For me, the mall is a constant in an otherwise chaotic world, an urban temple where wives and sisters and mothers and daughters know they can find peace. Shopping is about more than acquiring baubles and toys—sometimes the sales rack is our fast track to self-improvement. I always feel confident and in charge while shopping, leaving the mall with both manicure and job well done. I'm at peace with the fact that retail therapy makes me happier than almost anything in the world.

I am not recommending you bound off to the mall and spend willy-nilly, however. I always advocate shopping smart, and thus the last pages of the book present my ten commandments of shopping, which establish rules for purchase as good as they

come. After all, the point of restraint isn't to kill the joy in the one thing you like to—and occasionally have to—do. Whether you're an ex-spendaholic who can't open her wallet without flashbacks, a thrifty earth mama with a retail identity crisis, or a chic career girl with one too many pairs of shoes (hello, I can relate), I hope this book will give you 101 fabulous reasons to cast your guilt aside and indulge.

Happy shopping!

Jessica Waldorf

"The quickest way
to know a woman is to go
shopping with her."

MARCELENE COX

Chapter One

JUSTIFICATIONS

1

There might be a sale—
you'll never know if you
don't go!

2

If you wear it to work,

it's tax-deductible.

3

It's a happy memento
that will last a lifetime.

4

Making sure

your children aren't

blue is worth going

in the red.

5

Motivational
purchases will inspire
your weight loss.

6

Free backstage pass!

7

You've got to find the
perfect shoes for your new
job/house/car/cat.

8

Those shoes just scream "corner office."

You need to justify buying that Wonderbra.

10

Purple is so
in this year.

11

With a new fuzzy sweater,
you won't even be able
to see the cat hair.

❧ 12 ❧

You never know

when it might

come in handy!

13

Really,

you can never

be too prepared.

~~14~~

It could be necessary

for your survival.

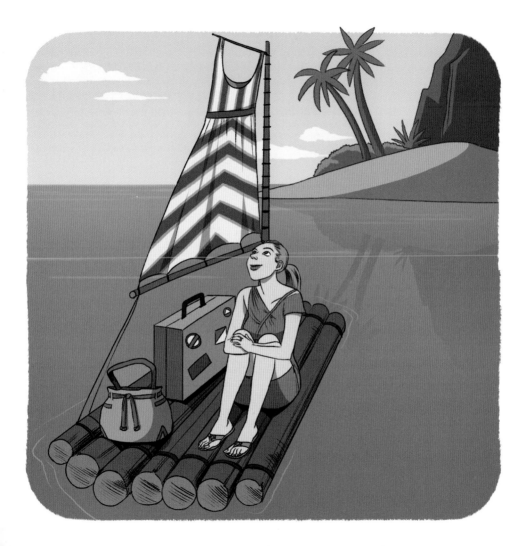

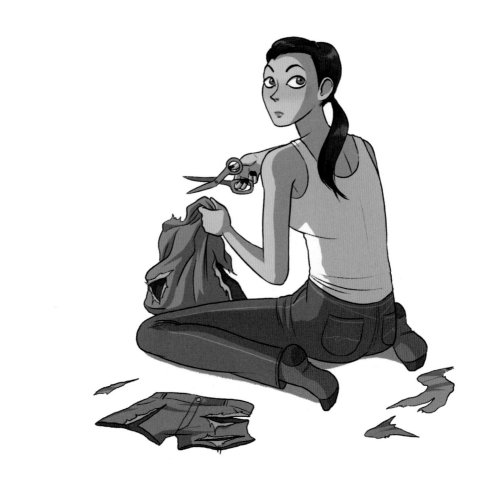

15

Your last one has a tear.

16

"Can we discuss your 'shrinkage' problem?"

17

The world's a dangerous place—better get two.

 18

What if it's

discontinued?

Better get seven!

❧19❧

You can never have

too many.

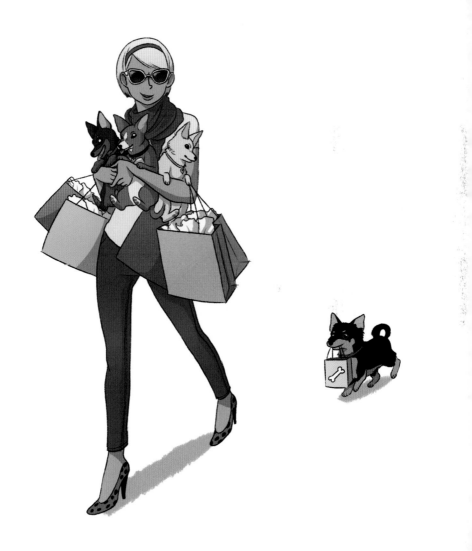

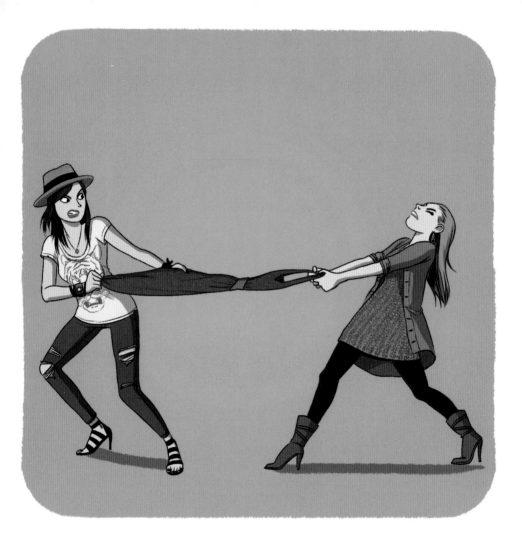

🙢 20 🙢

If you don't buy it now, someone else will!

❧ 21 ❧

… Or it might cost twice

as much later.

22

You can't undo
bad first impressions.

23

. . . Or bad second impressions.

Chapter Two

SALE-ABRATIONS!

24

A big promotion

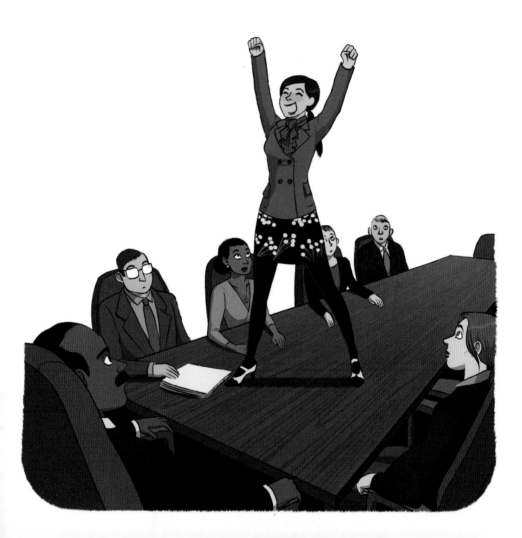

25

. . . or a bad day at work.

A lotta weight loss

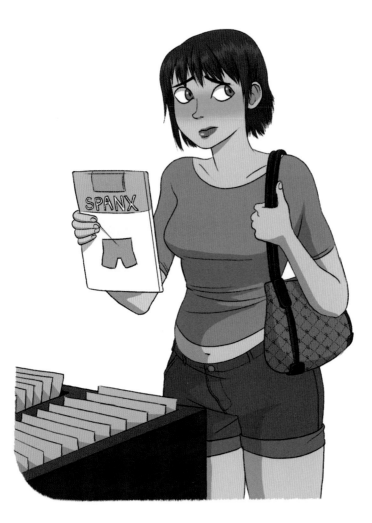

27

. . . or a little weight gain.

28

A new boyfriend

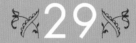

29

. . . or no boyfriend.

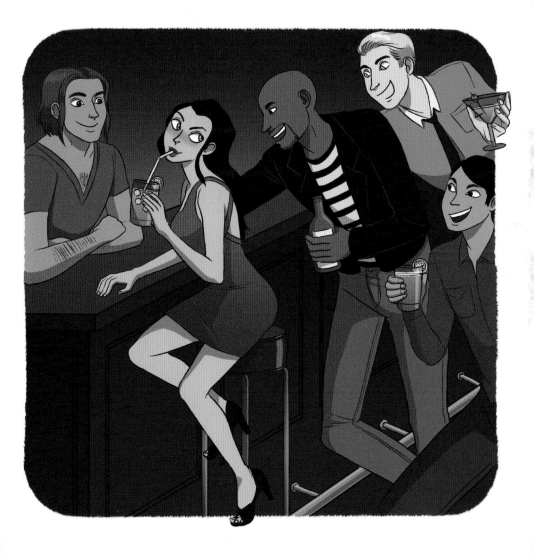

30

Marriage boredom

❧ 31 ❧

. . . or a new lease on life.

☙32☙

Because you've been

so good!

33

... Or because you've

been so bad.

34

Because it makes you

look younger

35

. . . or because it makes you look older.

36

You'll support
a starving actress

37

... or land yourself

a starring role.

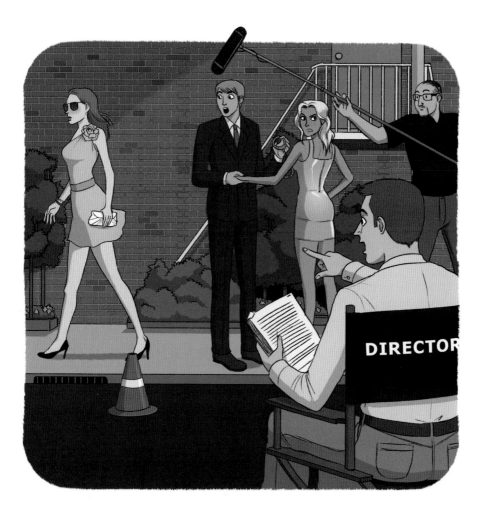

Chapter Three

HEALTH BENEFITS

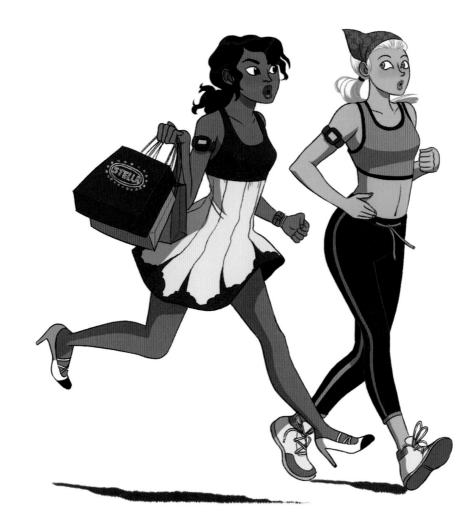

38

Shopping burns calories.

39

New shoes are cheaper than Botox, a tummy tuck, or a weekly personal trainer!

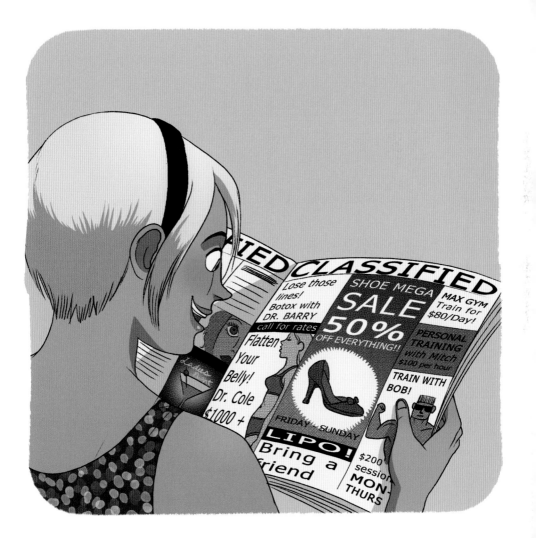

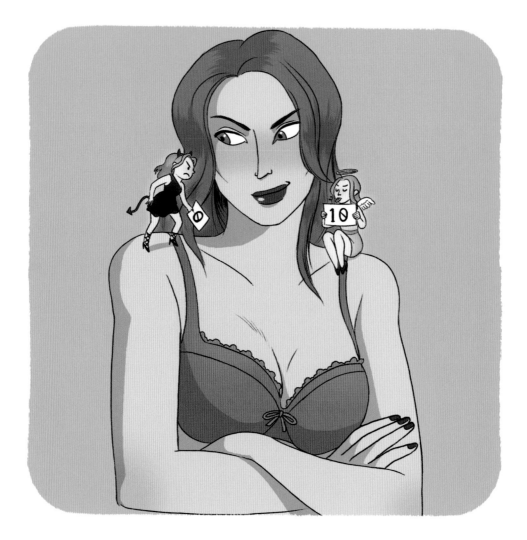

40

Your inner critic is no match for
a sexy pink push-up.

~41~

Nothing says
renewed-motivation-to-work-out
like a new gym outfit.

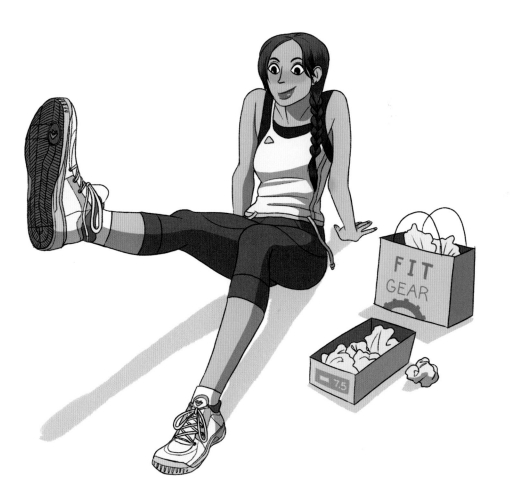

🙢42🙠

It's all about the thrill

of the hunt.

43

Some call it couture;
you call it camouflage.

44

You *have* to get away from this desk.

45

You *have* to get away

from this nest.

46

You *have* to get away
from this mess.

~47~

Bright colors make

people happy!

48

There are real obligations
that go along with being
so good-looking.

49

Don't underestimate

the joys of reconnecting

over retail

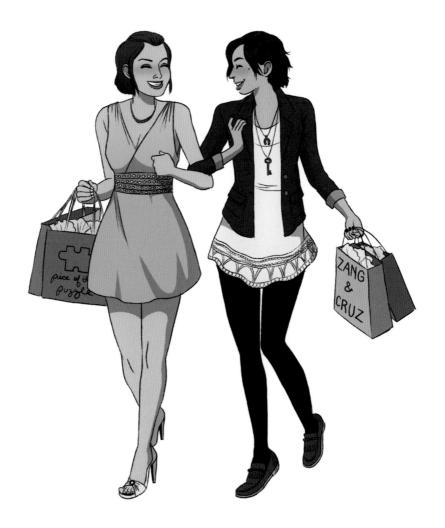

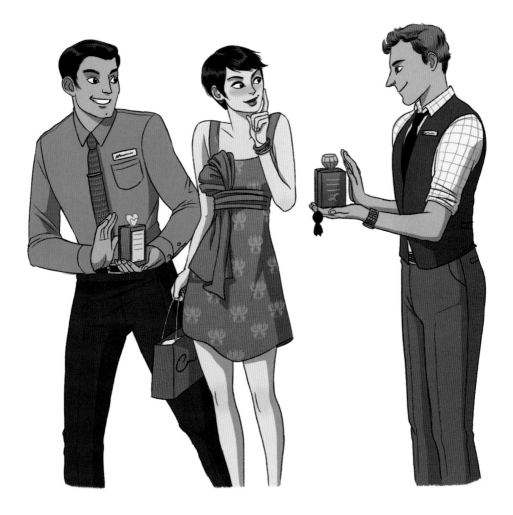

50

... or the feel-good endorphins
of visual stimulation

 51

. . . or the invigorating

benefits of comparison

shopping.

~52~

Organizing your closet will
cause you to become completely
organized in all other
areas of life.

~53~

You've got to learn to let go.

Chapter Four

YOU CAN'T SAY NO WHEN . . .

54

The "Everything Must Go" sale.

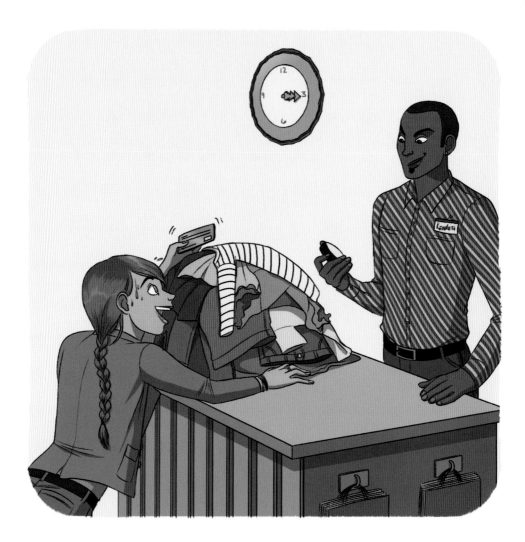

55

The 15.5 percent off

defective merchandise

on Friday between 3:00 and

3:15 (a few exceptions

may apply) sale.

Friends and Family

discount, baby.

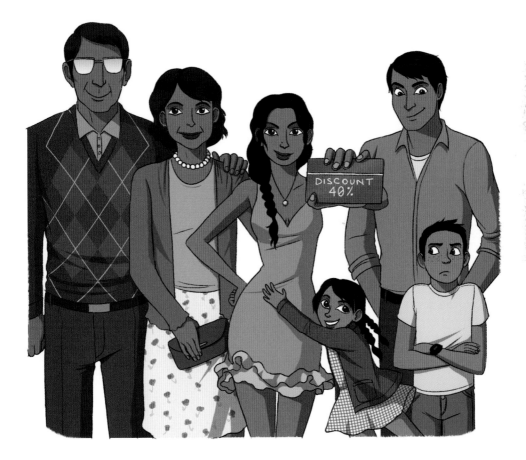

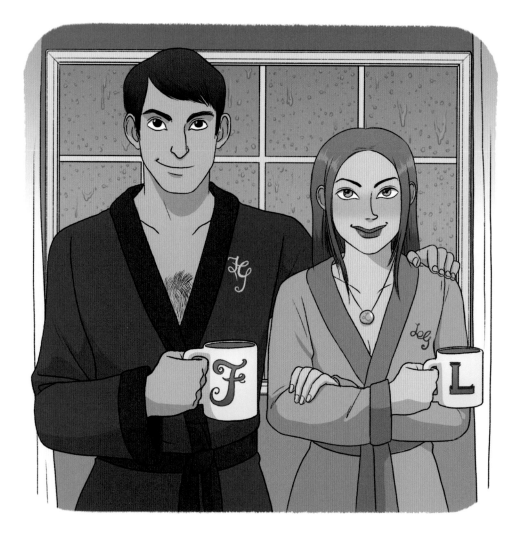

57

Two words . . .

free monogramming.

 58

Three words . . .

free gift wrapping.

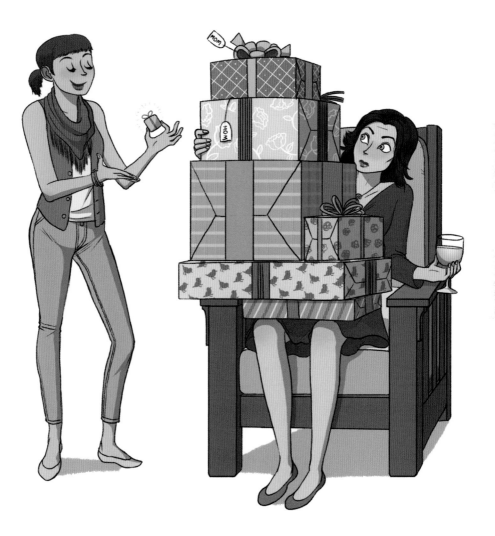

59

You just saved $978

on your car insurance!

Tax-free cities.

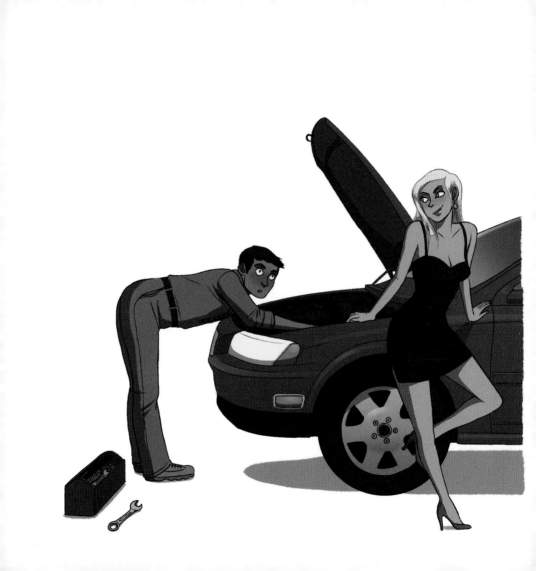

61

Splurging now may encourage future discounts.

62

Michelle Obama has one.

63

Paris Hilton has one.

It's a limited edition.

65

It'll get you that many miles

closer to Aruba.

66

It looks like its more

expensive cousin.

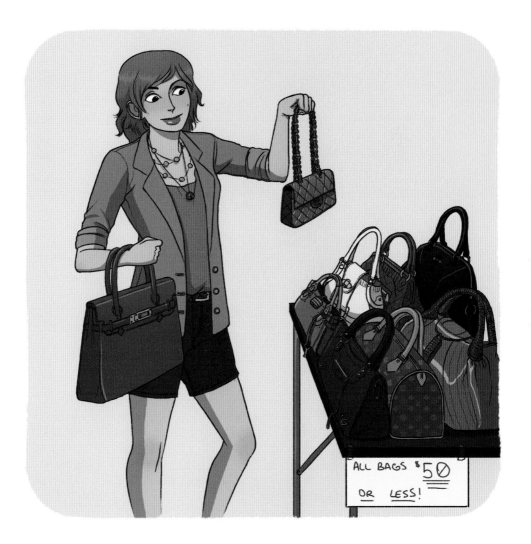

ALL BAGS $50 OR LESS!

67

It ain't

gonna spend itself.

68

Look how good you look
after two martinis!

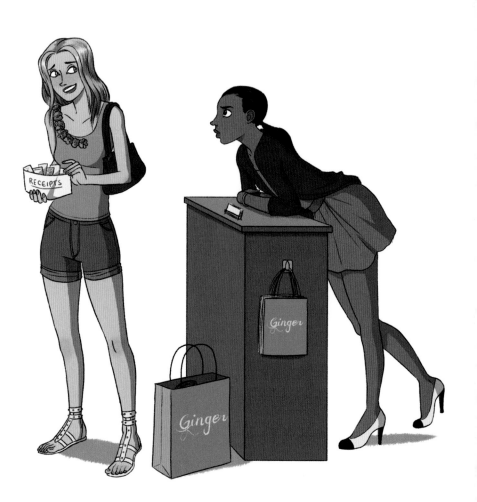

69

... And you can always

return it tomorrow.

Chapter Five

THINK OF THE CHILDREN

70

Responsible shopping fuels America's economic prosperity.

71

Locally owned businesses build strong neighborhoods.

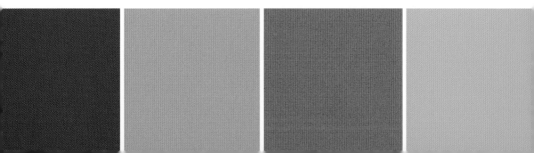

72

You'd hate to think that some poor, illegally employed child was wasting his or her time.

73

If you don't visit
a *variety* of retailers,
you may be inadvertently
encouraging a monopoly.

74

You can't take it with you.

✤75✤

If we only bought

what we needed,

millions of people

would be out of jobs.

~ 76 ~

You gave all your

good sweaters

to charity.

77

It's a future heirloom.

78

The more clothes you have, the fewer loads of laundry you have to do—think about how much water you'll save!

Chapter Six

'TIS THE SEASON

79

January:

Post-holiday sales

and gift-card remainders.

A match made in heaven!

80

February:

Because he deserves it!

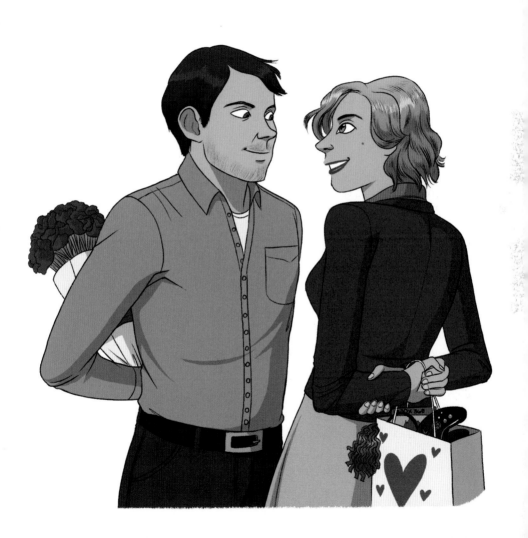

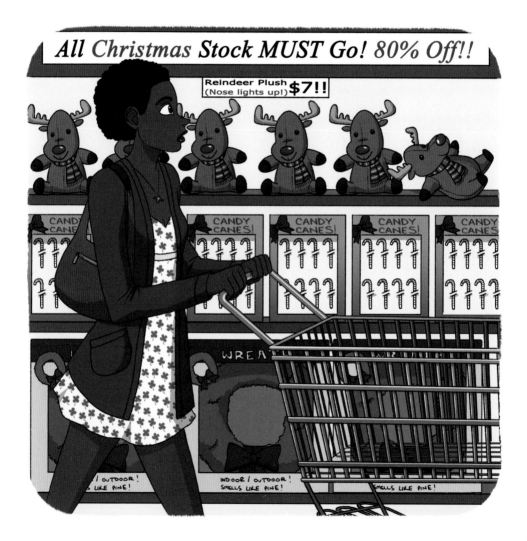

81

March:

Christmas is only

nine months away.

 82

April:

Is there a better use

for your tax refund?

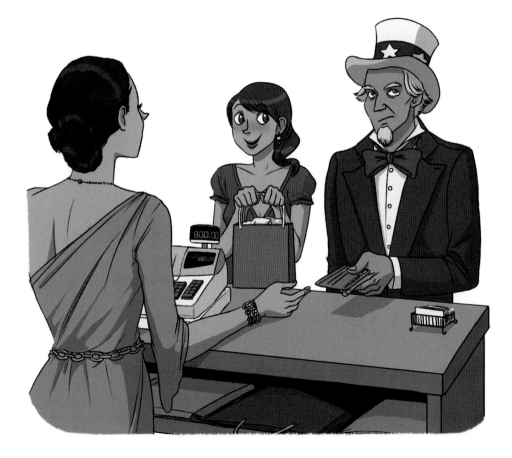

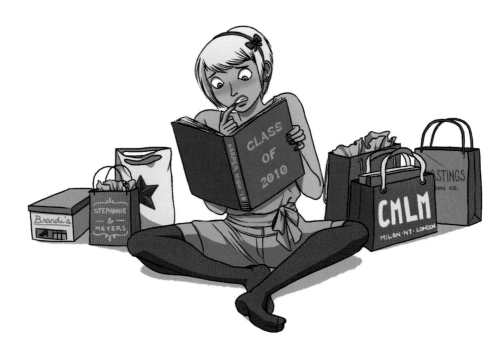

~ 83 ~

May:

Your next reunion

is coming up.

You know . . . eventually.

84

June:

Dads and Grads season!

85

July:

What's more patriotic than celebrating your right to life, liberty, and the pursuit of cute summer sandals?

~ 86 ~

August:

Letting your kids start school
without the right outfits could
be the social faux pas
they never recover from.

87

September:
Only nine months
till beach season!

88

October:

Permanent bragging rights.

89

November:

Black Friday! Cyber Monday!

The weekend in between!

90

December:

Because it's from Santa.

Chapter Seven

THE SHOPPER'S COMMANDMENTS

THOU SHALT BUY IT IF . . .

91

It's a basic.

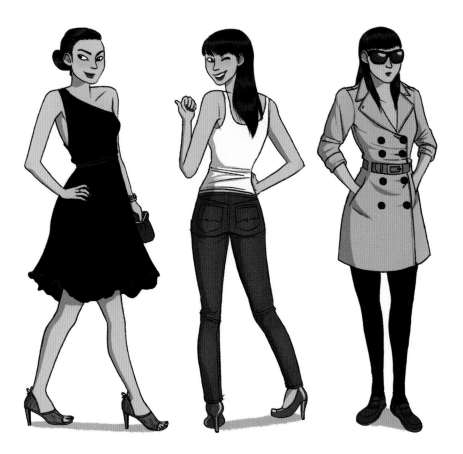

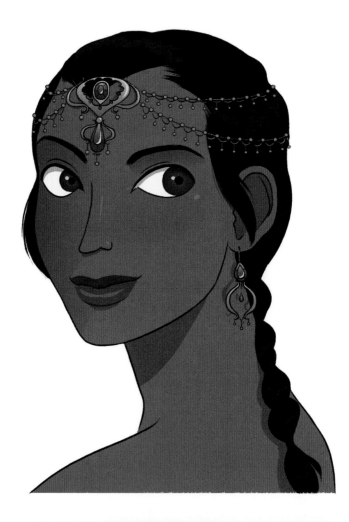

92

It's a statement.

❧93❧

It makes everything

else you own look better.

It's one of a kind.

95

It's the last one
in your size

96

. . . or *almost* your size.

97

You've been thinking about it
for more than a month.

98

You don't have it
in that color.

It'll last forever.

100

It makes you feel fabulous.

101

Because you're worth it!

About the Author and Illustrator

Jessica Waldorf is a New York City writer and fashionista who lives by the principle "Carpe Dior!" Raised frugally in the South, she was forever changed when her aunt introduced her to the holy grail of shopping: the outlet mall. This is her first book.

Carly Monardo is an SVA graduate/illustrator/animator/ compulsive shopper/twin sister living in Brooklyn, New York, with her fiancé and their dog, Commissioner Gordon. You can see more of her work at www.whirringblender.com.

"Anyone who lives within their means suffers from a lack of imagination."

OSCAR WILDE

For new shopping excuses,
fashion tips, wardrobe stories,
and more, please visit
Jessica's website:

WWW.101REASONSTOSHOP.COM